IN-LINE SKATING

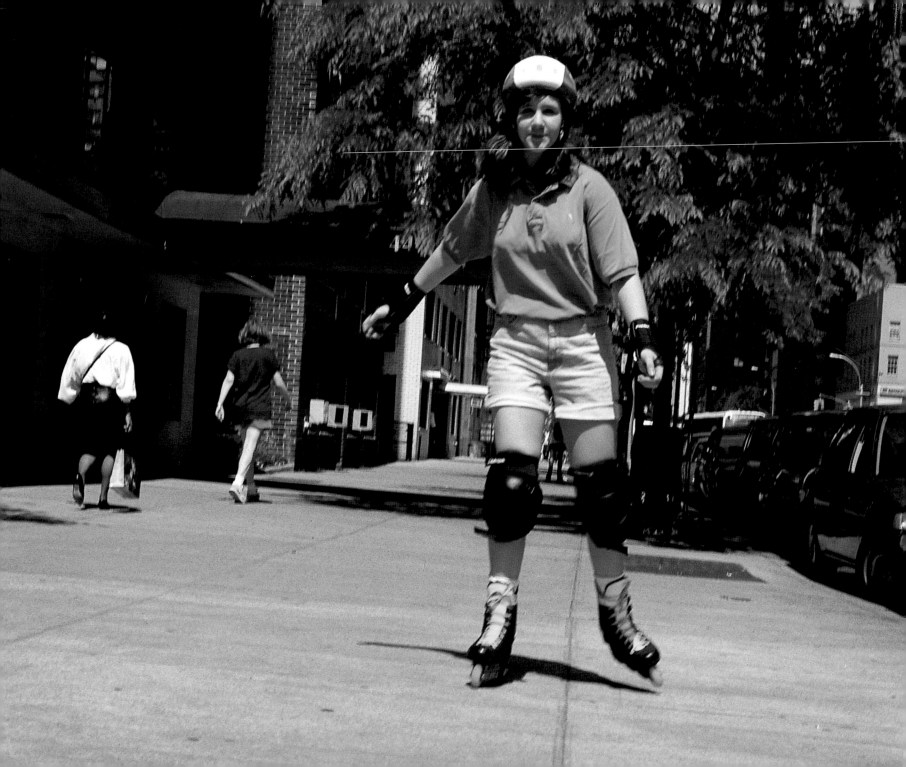

IN-LINE SKATING
A Complete Guide for Beginners

George Sullivan

Illustrated with photographs

COBBLEHILL BOOKS **Dutton New York**

PICTURE CREDITS

Aime LaMontagne, 17, 20, 24, 26, 29, 31, 35, 36, 42, 43, 45;
George Sullivan, 2, 9, 10, 14, 18, 21, 23, 38, 39, 40;
Wendy Tucker, 6, 13, 27, 34, 47.

Library of Congress Cataloging-in-Publication Data
Sullivan, George, date
In-line skating : a complete guide for beginners /
George Sullivan ; illustrated with photographs.
p. cm.
ISBN 0-525-65124-1
1. In-line skating. I. Title. GV859.73.S85 1993
796.2'1—dc20 92-25896 CIP AC

Published in the United States by Cobblehill Books,
an affiliate of Dutton Children's Books,
a division of Penguin Books USA Inc.
375 Hudson Street, New York, New York 10014

Printed in Hong Kong
First Edition 10 9 8 7 6 5 4 3 2 1

Contents

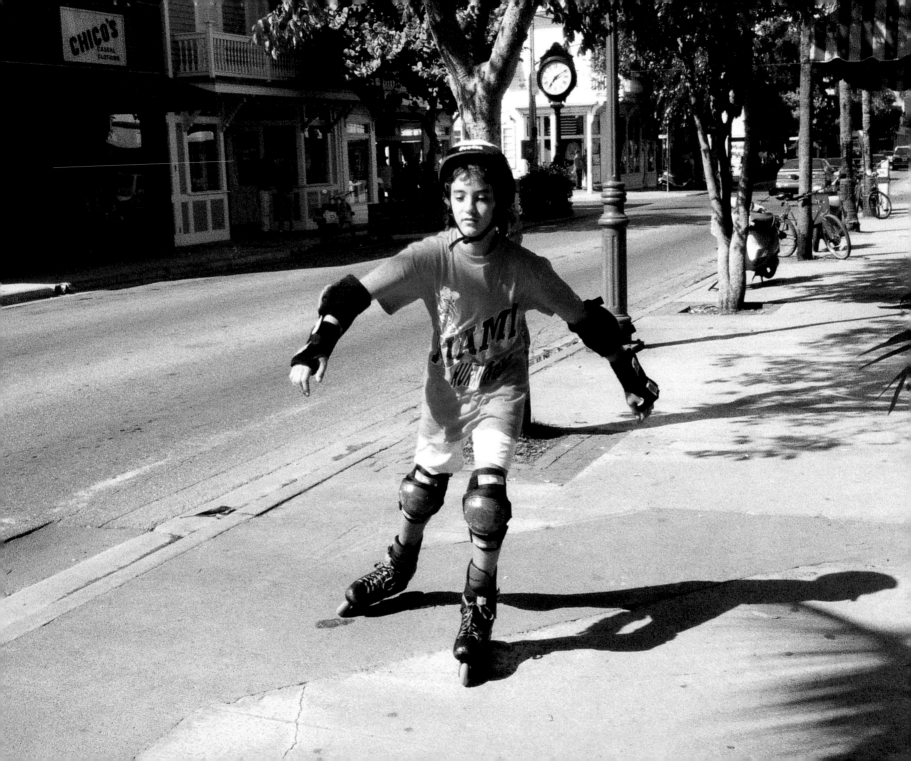

1 Wheel Appeal

"The sport of the '90s" is what it's called. It's in-line skating, also known as rollerblading or just "blading." From the seaside boardwalks of southern California to New York's Central Park, it has taken the country by storm.

It's different from roller skating because the shoe of the skate is mounted atop three, four, or five wheels in a line, not two sets of wheels side-by-side. The result is a smooth, almost friction-free ride, more like skiing or ice skating than roller skating.

Most kids who have tried the sport say they learned quickly. Balance is one of the main things. Learning how to stroke rhythmically is important, too. The hardest part is learning how

In-line skating — "the sport of the '90s."

to stop. But whether you're a "natural" who takes to the sport immediately or a person who requires a few lessons from an instructor, you're going to have fun right from the start.

In-line skating dates to 1980, the year that Scott and Brennan Olson of Minneapolis founded Rollerblade, Inc. The brothers had seen a primitive version of an in-line skate in a Midwest sports shop. Since the technique of in-line skating is very similar to that of ice skating, their plan was to manufacture and market the skate to hockey players who wanted to train for their sport in the off-season. The players wouldn't need frozen ponds or ice rinks; they could skate on concrete or asphalt.

The skates the Olson brothers developed were very different from old-fashioned roller

skates. The boot, made from synthetic materials and padded to fit like a ski boot, was light in weight. The polyurethane wheels, arranged one behind the other, absorbed shocks much better than metal, providing a smoother ride.

The new in-line skates performed much like an ice skate, except for stopping. For that, the Olsons developed a heel brake for the right skate. (In ice skating, you stop by turning your skates so that they form a right angle with the direction in which you're traveling.)

The new skates sold briskly. Before long, however, the brothers realized that hockey players represented only a small part of their business. Skiers had found that the in-line skates enabled them to duplicate many of the techniques of skiing, even when it came to practicing turns. They also found the skates to be helpful in building leg strength.

Cyclists and rowers had begun using the skates for practice and exercise—for cross training, that is. A track coach at Louisiana State University recommended them to his athletes to break the monotony of running everyday.

During the mid-1980s, blading started to be-come all the rage in California. People who had never become skilled in ice skating or roller skating found that the molded boots of in-line skates provided far more ankle support than any ice skates or roller skates they had ever tried. In addition, in-line skates offered greater stability than ice skates and were more maneuverable than roller skates.

Sure, falling down is a hazard, and scrapes are not uncommon. Stiff wrist guards, which both protect against wrist injuries and also help absorb the impact of falls, are vitally important. Pads for the elbows and knees and a lightweight helmet are also necessary. Once a skater becomes skilled and takes all the precautions, in-line skating is not dangerous.

By the end of the 1980s, in-line skating had caught on across the nation. Blades could be spotted about anywhere there happened to be smooth pavement without steep hills and automobile traffic. Bike paths became popular courses for bladers. Blading trails and rinks began to appear in California and some other parts of the country.

The Olson brothers sold their company in 1984 to North American Sports Training Com-

In learning to skate, balance is the main thing, say the experts.

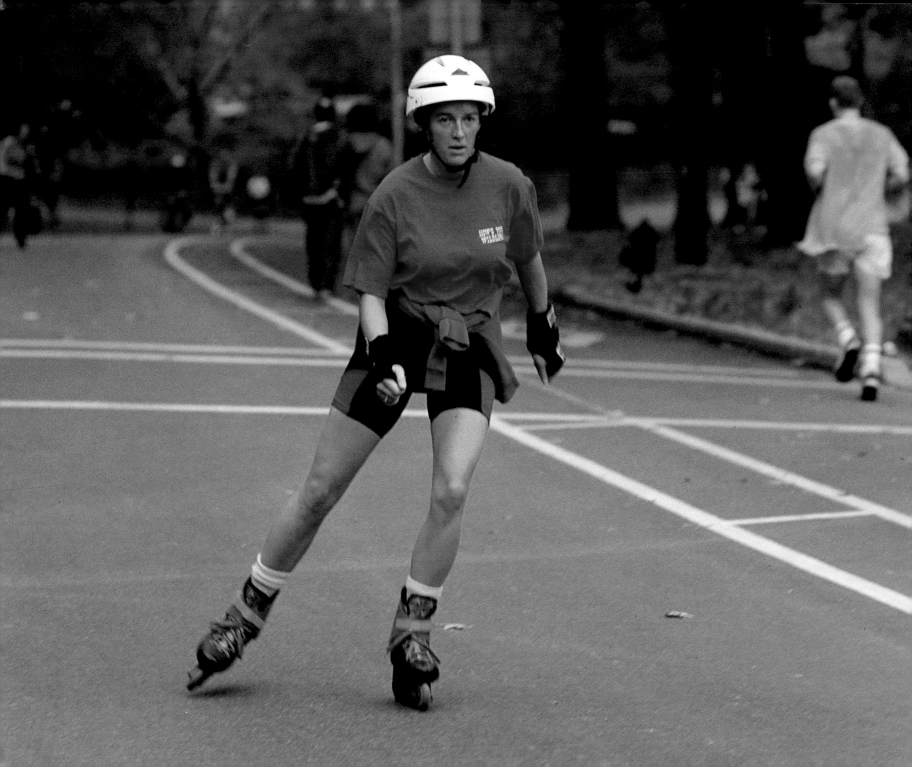

pany in Minneapolis. But they continued to be active in the sport. Scott formed SwitchIt, a company that makes an in-line roller skate that converts to an ice skate, using the same boot. Brennan, continuing his relationship with Rollerblade, Inc., developed the Lightning, an in-line skate built with a glass-reinforced nylon frame that makes the skate much lighter than the usual metal frames. And the skate wheels have a simplified mounting system.

In recent years, several other companies have entered the field. They include Ultra-Wheels, another Minneapolis-based firm, whose line of skates has been endorsed by hockey great Wayne Gretzky, and Bauer, a division of Canstar Sports, a leading manufacturer of ice skates.

During the late 1980s and early 1990s, in-line skating boomed. The number of skaters doubled and redoubled. And redoubled again. Equipment sales soared. By 1991, more than a million people had bought in-line skates.

Roller hockey leagues were established all across the country. Skate racing and stunt skating developed their own followings.

In recent years, the trade name Rollerblade® has become so widely used that many people apply it to all types and brands of in-line skates. Like Kleenex and Xerox, it's a case of a brand name becoming a generic name.

The terms "blades" and "blading" are coming to replace "skates" and "skating." The skates themselves are often called blades.

No matter what set of terms are used to describe the sport and its equipment, one thing is certain—in-line skating is no fad; the sport is here to stay.

Blading in New York's Central Park

2 Your Skates

Take your time picking out your skates. At first, the number of different kinds may bewilder you. But when you explain that you're interested in skating for fun, not in speed skating or artistic skating (not yet, anyway), it narrows your choices.

Skates consist of boots, a sturdy frame that encloses the wheels, and the wheels themselves. Some boots offer a hinged cuff at the top for added support. It fits snugly around the ankle, closing with a ratchet-style buckle.

Be sure the boots that you select are vented; that is, they should provide a system for permitting the circulation of air within the boot. Your feet sweat when you skate. If there's no venting system, the boots can become uncomfortable during long skating sessions.

The frame should be of rigid construction. Turn the skate over and try to twist the frame. There should be only the slightest "give."

Quality frames are made of nylon with fiberglass reinforcing. Ultra-Wheels, however, offers a five-wheeled racing skate, the Ultra ST, with a frame made of titanium, a very hard, very light metal.

In-line skates are not cheap. They can cost anywhere from $75 to $400 a pair. There are cheaper skates available, but they can't be counted on for serious skating. Cheap skates can even be hazardous. You can also rent skates, at least until you decide whether you're going to want to become a real enthusiast. Most stores offer rentals.

If you choose to rent, it's a good idea to bring

an adult with you. Most rental outlets ask for a substantial deposit to be posted as protection against the loss of skates. The deposit can run as high as $200. A credit card usually will be accepted in place of cash.

You may wonder why some skates have three wheels and others four. It has to do with the size of the skates. Small-size skates have a short wheelbase (the distance from the center of the front axle to the center of the rear axle). It can accommodate only three wheels. Larger-size skates, with their longer wheelbases, can take four wheels.

There are also five-wheeled skates. These are for speed skating (see Chapter 13). Unless you're highly skilled, an advanced skater, stick to skates with either three or four wheels.

No matter how many wheels your skates happen to have, be sure to get the best fit possible. Remember to wear cotton sport socks when you go to have the boots fitted.

The fit should be snug, but not tight. Once you've tried on the skates, and have laced them up or buckled them tight, try wiggling your toes.

Most skaters prefer four-wheel skates.

There should be enough room to allow the toes to move a little.

Stand up. The toes should barely touch the ends of the boots when you're standing.

While still standing, bend deeply in the knees; squat down. This should cause your toes to pull back slightly from the front of the boot, and the

For speed skating, you need five-wheelers.

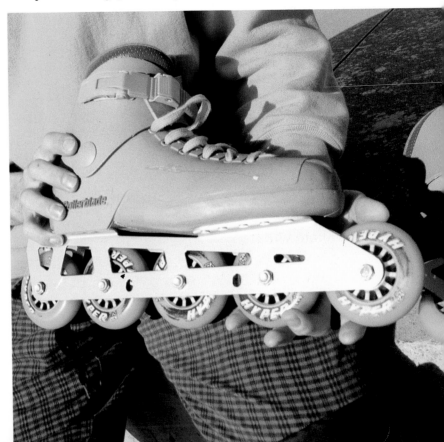

Small-size skates have only three wheels.

14

boot should allow this. The fit shouldn't be so tight the toes can't move.

Inside the boot, there's a padded insole or footbed, also called a liner. Besides providing foot comfort, it absorbs roadway jars and jolts when you skate. In more expensive skates, the footbed may be made of "memory foam," a soft plastic material that molds itself to the shape of your foot. Such liners can be bought separately.

The footbeds should give you good arch support and, in general, help to prevent your feet from rolling inward within the skates. In other words, the liners help to stabilize your feet. Without stability, you won't be able to control your skates properly.

Your parents are likely to be happy to learn that a pair of boots can accommodate liners of more than one size. The proper fit allows some room for your feet to grow. When they do, you may not necessarily need to buy new boots. All you may require are liners of a larger size.

Skate wheels come in several different sizes. As a young beginner, you'll no doubt use skates with wheels that are 64 mm in diameter. There are also wheels that are 70 mm and 76 mm in diameter. (The difference between 64 mm and 76 mm is equal to about one-half inch.) The bigger the wheels, the stronger the push-off and the faster you travel.

Speed is also affected by wheel hardness, which is expressed by a durometer rating. The higher the durometer number, the harder (and slower) the wheel. Rollerblade, Inc.'s Blade Runner, a recreational skate, has a durometer rating of 88A. The company's Racerblade 908, a racing skate, has a durometer rating of 78A.

Smaller, harder wheels may not enable you to travel with bullet speed. But you'll still be able to burn up the road, and you'll get the added benefit of greater control, a feature that will provide you with more pleasure than merely going very fast.

Another way to upgrade the performance of your skates is by using high-quality bearings. Rollerblade, Inc. offers five kinds of bearings: AA, A, BB, B, and C. High-performance AA bearings are for racing skates.

The same day you purchase your skates, also arrange to buy the protective gear you need — wrist guards, elbow pads, kneepads, and a helmet. Be sure to wear such equipment from the very first day you put on skates.

3 Safety Equipment

Once you're the least bit skilled on in-line skates, you'll find you can whiz down gentle slopes at speeds that thrill you. The ground flies by in a blur and the wind whistles past your ears. If your skates had a speedometer, it would probably report that you're traveling at from 15 to 20 miles an hour.

While that kind of speed can make for exciting fun, it can be hazardous. Accident victims are sometimes first-time skaters who are often skilled in roller skating or ice skating and assume that in-line skating is the same. It's not. Not only do you zip along at a much faster speed, but stopping is trickier.

Many injuries happen to beginners who do not know how to stop or turn. Bladers also fall because they do not know how to glide over sidewalk cracks, or skate over sandy spots or through water. Black-and-blue marks, sprains, and even fractures—and the pain that goes with them—are the result.

The safety gear discussed in this chapter will help to protect you from injuries. Never skate without it.

The most common blader injury is a sprained or broken wrist. When a beginner goes down, he or she usually falls forward and tries to break the fall by sticking out both hands.

Wrist guards with stiff plastic inserts protect against injury to the hands and wrists. They can be purchased at the shop where you buy or rent your skates. Be sure they fit snugly.

Elbow pads and kneepads are usually made of nylon, have foam padding, and plastic caps.

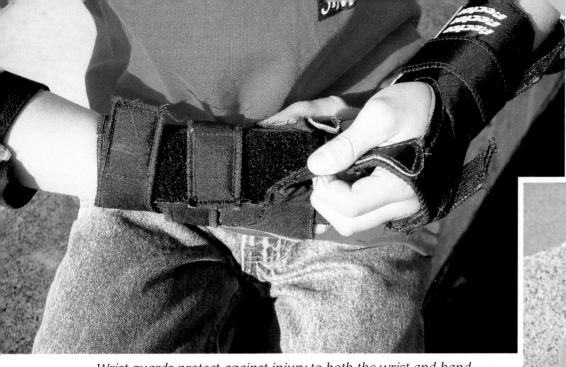

Wrist guards protect against injury to both the wrist and hand.

Elbow pads should fit snugly.

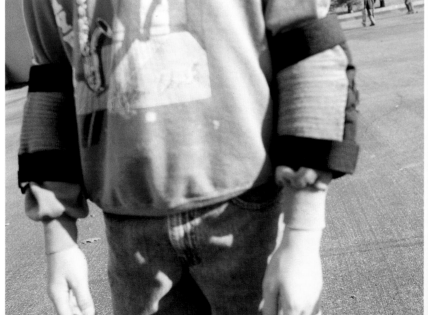

Shell plastic kneepads are vital, too.

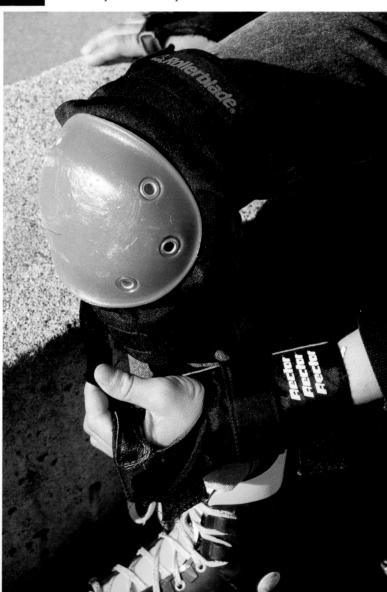

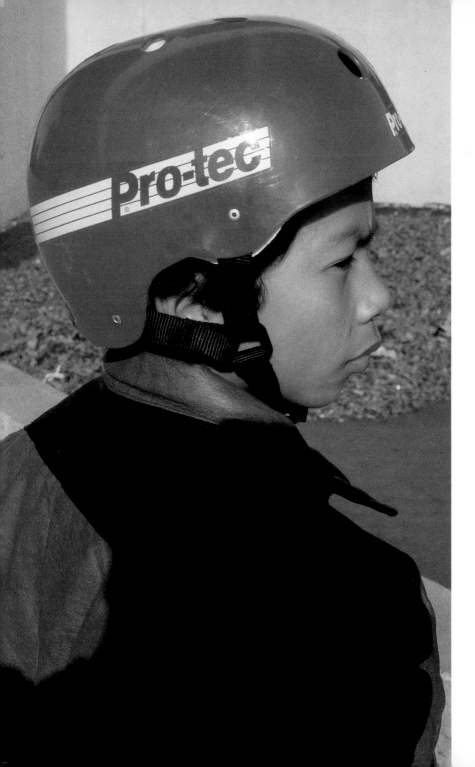

Some take the form of elastic sleeves with Velcro closures.

The most feared injuries are to the head. That's why you shouldn't go without a helmet. A local bicycle shop is likely to have a wider selection of helmets than a skate shop.

Of course, safety equipment alone does not guarantee protection against injury. What's equally important is knowing the proper technique for keeping your balance, stopping, and turning. The chapters that follow cover these and other basics.

Never skate without wearing a helmet.

4 First Time On Skates

The first time you put on skates, you should only try to get the "feel" of them. Instead of heading for a neighborhood sidewalk or strip of asphalt, pick out a level patch of lawn. The grass will prevent the wheels from turning fast and, if you should happen to fall, it will cushion your landing. Just be sure the grass is dry and the ground solid, not mushy.

If you are learning to skate at an indoor rink, there may be a carpeted area you can use. Ask the manager.

Begin by taking a few short walking steps, with the toes of each skate pointed outward. Some instructors call this a "duck walk."

If you feel wobbly, as if you might be going to fall, bend your knees. Bend at the waist, too.

Extending your arms out to your sides will also help you in keeping your balance.

As you get used to your skates, add more speed to your steps. On each step, be sure to keep your toes pointed outward.

In-line skating is essentially a series of pushes and glides. You push with one skate and glide with the other. You're able to push because you turn the skates outward so that the wheel edges dig into the surface. The duck walk, with the toes pointed outward, is good practice for the push phase of the stroke.

Skaters say, jokingly, that the hardest thing about skating is falling down. And it's true—falling is never any fun.

When you do fall, try to use your pads. Re-

19

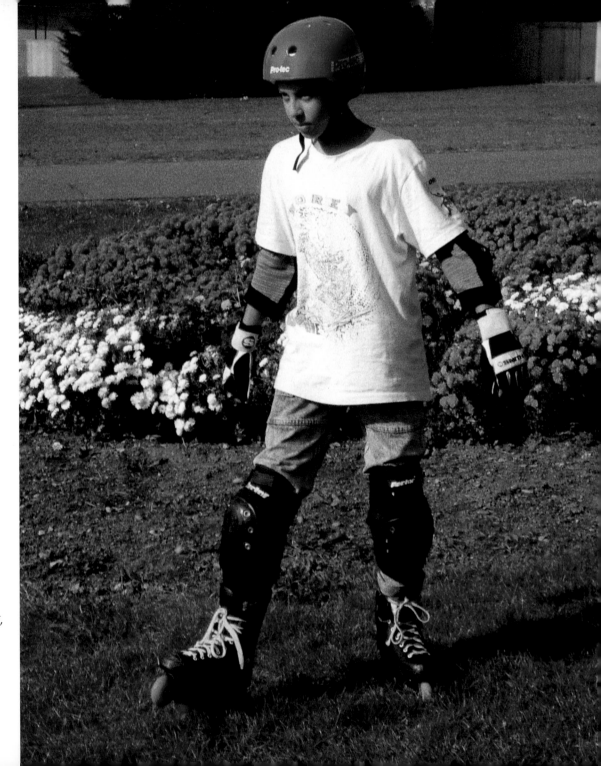

For your first attempts at skating,
try the duck walk.

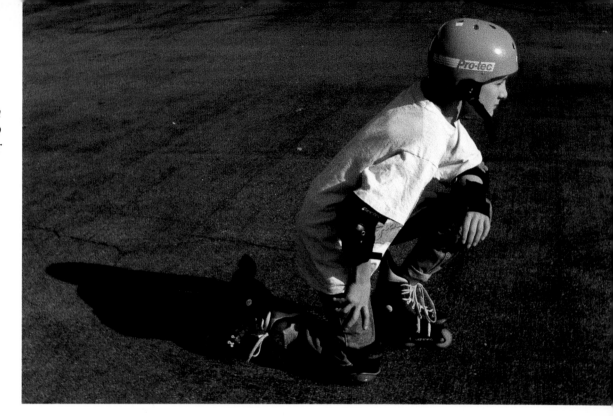

In getting up after a fall, kneel on one knee, than push yourself up to a standing position from the other foot.

member, you have six protected contact points (two kneepads, two elbow pads, and two wrist guards). Use one or more of these to absorb the impact of the fall.

For example, if you feel yourself going forward, and you stick your hands forward, try to thrust a knee forward, too. Try to get a kneepad to absorb some of the impact. If you fall to the right or to the left, attempt to get an elbow pad involved.

After the initial impact, try to continue to roll.

If possible, get a shoulder and your back to help cushion the fall.

If there's a grassy area adjacent to where you're skating, head for the grass when you feel a fall coming. It provides a softer landing area.

Once you're down, there's an easy way to get up. Kneel on the surface, then slide one skate forward until it is opposite the other knee. Now you're kneeling on one knee. Put your weight on the other skate and push yourself to a standing position.

5　　Getting Rolling

"The nice thing about this sport," says one blader, "is that if you can walk, you can skate." That might not be exactly true, but it's pretty close.

In-line skating is not hard to learn. Anyone who has skated or skied is almost certain to take to it quickly. But even for a beginner, it's easier to learn than either ice skating or roller skating.

The whole idea is to push from one skate and glide on the other, and do it smoothly and rhythmically.

Pick out a flat, smoothly paved surface. Look for an empty parking lot, a hard-surfaced tennis court, or a stretch of park road where there is no traffic. A paved bike path is also good if no cyclists are using it. Be sure the surface has no bumps or potholes and is free of pebbles and twigs.

The proper skating position is a slight crouch. You bend at the knees and waist as if you were about to sit down.

Bending at the knees is very important. When your knees are bent, your center of gravity is directly above your skates, and you're evenly balanced.

Once you feel comfortable with the basic stance, try stroking, pushing off with one skate and gliding on the other. To get a forceful push, turn your foot outward and push from the entire row of wheels, not just the front or back wheels.

To get used to what skating feels like, glide as far as possible after each push. Once you've finished a glide, bring the other skate forward.

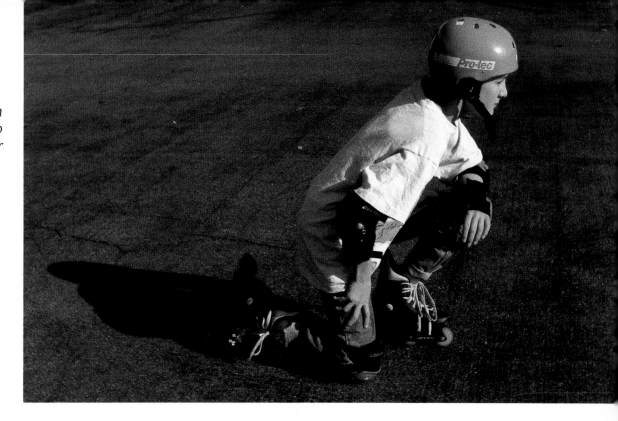

In getting up after a fall, kneel on one knee, than push yourself up to a standing position from the other foot.

member, you have six protected contact points (two kneepads, two elbow pads, and two wrist guards). Use one or more of these to absorb the impact of the fall.

For example, if you feel yourself going forward, and you stick your hands forward, try to thrust a knee forward, too. Try to get a kneepad to absorb some of the impact. If you fall to the right or to the left, attempt to get an elbow pad involved.

After the initial impact, try to continue to roll.

If possible, get a shoulder and your back to help cushion the fall.

If there's a grassy area adjacent to where you're skating, head for the grass when you feel a fall coming. It provides a softer landing area.

Once you're down, there's an easy way to get up. Kneel on the surface, then slide one skate forward until it is opposite the other knee. Now you're kneeling on one knee. Put your weight on the other skate and push yourself to a standing position.

5 Getting Rolling

"The nice thing about this sport," says one blader, "is that if you can walk, you can skate." That might not be exactly true, but it's pretty close.

In-line skating is not hard to learn. Anyone who has skated or skied is almost certain to take to it quickly. But even for a beginner, it's easier to learn than either ice skating or roller skating.

The whole idea is to push from one skate and glide on the other, and do it smoothly and rhythmically.

Pick out a flat, smoothly paved surface. Look for an empty parking lot, a hard-surfaced tennis court, or a stretch of park road where there is no traffic. A paved bike path is also good if no cyclists are using it. Be sure the surface has no bumps or potholes and is free of pebbles and twigs.

The proper skating position is a slight crouch. You bend at the knees and waist as if you were about to sit down.

Bending at the knees is very important. When your knees are bent, your center of gravity is directly above your skates, and you're evenly balanced.

Once you feel comfortable with the basic stance, try stroking, pushing off with one skate and gliding on the other. To get a forceful push, turn your foot outward and push from the entire row of wheels, not just the front or back wheels.

To get used to what skating feels like, glide as far as possible after each push. Once you've finished a glide, bring the other skate forward.

Turn one skate outward and push from the entire row of wheels; then glide.

Your weight shifts and the gliding skate becomes the pushing skate. Do this a few times, and you're skating.

It won't be long before you realize that you shift your weight from side to side when you're blading. Keeping your hands low and in front of you and allowing them to sway from side to side will help you in developing the proper side-to-side rhythm.

Some skaters have trouble developing a smooth skating stroke. Their strokes are short and choppy. They look more like they're walking than blading.

If this should happen to you, examine your stroke. Be sure you're getting a forceful push. This comes from having your weight concen-

trated over the pushing skate as you push. It's also vital to have the toes turned outward and to push from all the wheels at the same time.

If you come upon a trouble spot when you're skating, such as a patch of water or sand, and can't avoid it, it's best to stand up straight and simply glide through it without striding. Keep one skate slightly in front of the other.

Pavement cracks are another hazard. Cross these at a right angle, if possible, or at as close to a right angle as possible. When the surface is littered with small pebbles, leaves, twigs, or other debris, and you can't glide safely, take tiny steps that force you to shift quickly from one skate to the other.

If you know how to start, push, and glide, but

23

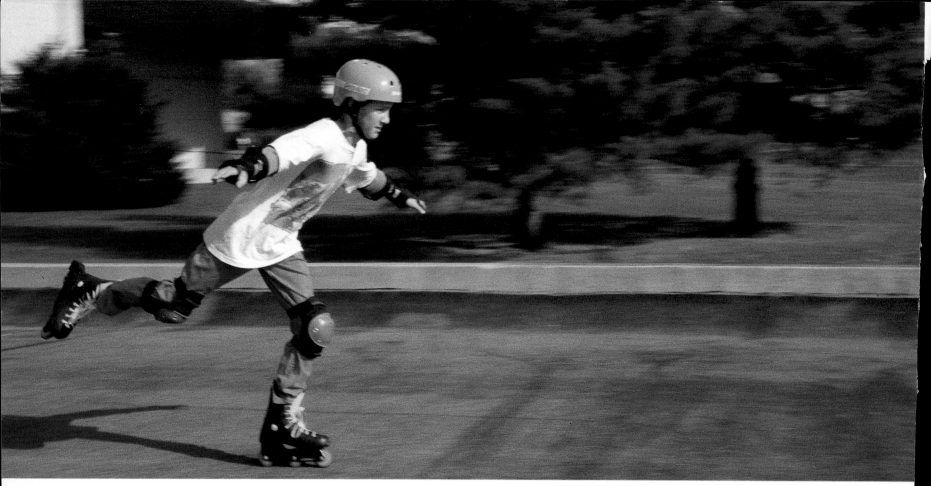

After you push, glide as far as you can on the other skate.

little else, a good way to stop is to simply skate into a grassy area, perhaps a lawn that is adjacent to the sidewalk on which you're traveling. The grass will bring you to a gentle stop. Just be sure the grass isn't wet or the ground soft.

Don't become disappointed if you're not able to "roll 'em" like an expert after your first skating session. It may take several tries before you feel comfortable. Just remember, the results are worth the time and effort.

6 How to Stop

If you ice-skate or roller-skate, you know that the in-line system of braking is unusual. It involves the use of a heel brake that is mounted to the rear of the right skate. It may take several practice sessions to become skilled in using it.

When you apply the brake, your left knee is bent and your braking foot is out in front of you.

From a glide, slide the right skate forward until the brake is about opposite the toe of the left skate. Bend the left knee and straighten your braking leg. At the same time, tilt the toe of the braking skate upward, then press the brake into the surface.

As you press down, extend your arms. This helps you in keeping your balance.

Be sure to keep your braking skate pointed forward. If it veers to the right or left, you won't stop efficiently.

One instructor tells skaters to imagine they're crushing a bug with their heel. "Anybody can step on a bug," he says.

Practice stopping while skating slowly. As you become skilled, increase your speed.

Instead of using the heel brake to stop, some bladers prefer the T-stop, which is also common to roller skating. It gets its name from the T the skates form when you execute the maneuver.

Glide forward with one skate in front of the other. Keep the skate that's in front pointed straight ahead. Concentrate your weight on that skate. Bend the knee.

Lift the trailing skate and turn the foot so as to

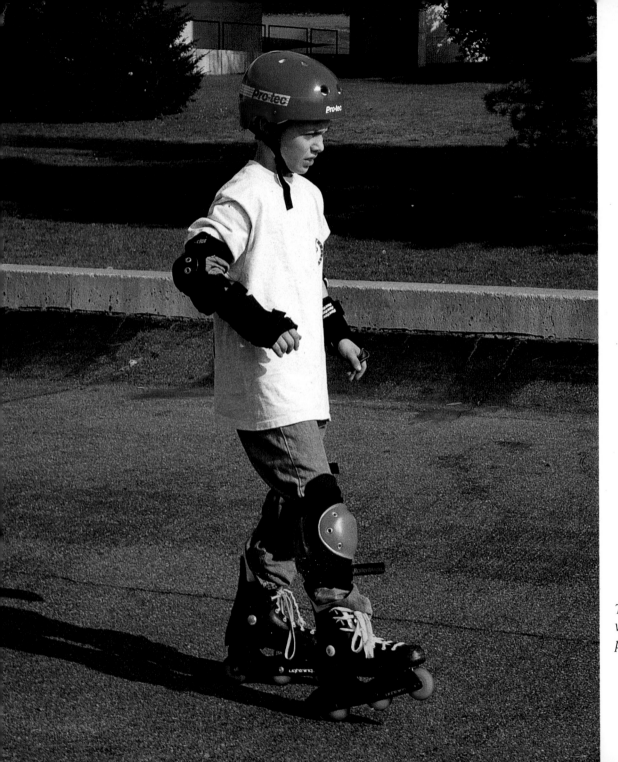

To stop, slide the right skate for-ward, tilt the toe upward, and push hard.

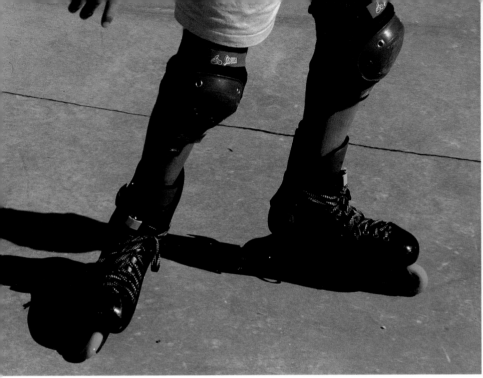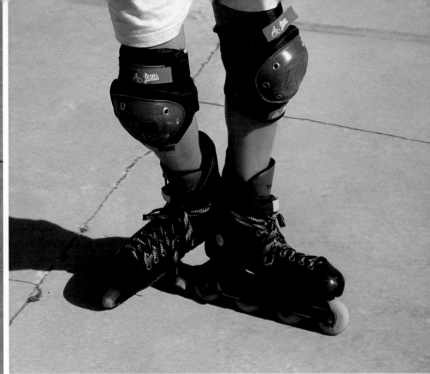

In executing a T-stop, draw the wheels of the trailing skate toward the front skate, thus forming a T.

form a right angle with the other skate. Lower the wheels of the rear skate to the ground. Then start dragging the wheels of the trailing skate closer and closer to the front skate until the two skates touch. By that time, you should have come to a complete stop.

Once you know how to stop, take some time getting used to your skates. Do some gliding. Glide with your knees bent; glide while standing erect.

Skate in a counterclockwise direction, then in a clockwise direction. (If you skate at a rink, you'll find the traffic moves in a counterclockwise direction.)

Glide with your skates together, your ankles almost touching. Glide with your skates wide apart. Glide only on the right skate, then only on the left.

And practice stopping. Practice until it feels natural.

7 *Swizzling*

Swizzling is a drill that instructors use to introduce advanced skating techniques. You can swizzle either forward or backward.

In swizzling, the wheels never leave the surface. You propel yourself, not by pushing off on one skate and gliding on the other, but by an in-and-out movement of the skates. It's something like the way a fish swims, with a simple wiggling motion.

Swizzling involves using the wheel edges. If you take lessons, "edge" is a term you'll hear often. It refers to each side of each set of wheels.

Skates have both inside and outside edges. On a pair of skates, the inside edges are those that face each other. When you stride forward, you push off from an inside edge. The outside edges are those on the outside of the wheels.

To swizzle forward, begin with your skates together, the heels touching, the toes apart. Bend your knees slightly. Put your arms out for balance.

Push from the inside edges of both skates at the same time, forcing your skates apart to about the width of your shoulders. At the same time, propel yourself forward.

When your skates are about shoulder-width apart, turn the toes inward and begin drawing your feet together, again propelling yourself forward.

Then repeat the maneuver, thrusting your feet apart by pushing off from the inside edges, and bringing the skates together again. As you continue the drill, you'll trace a series of hourglass figures on the surface.

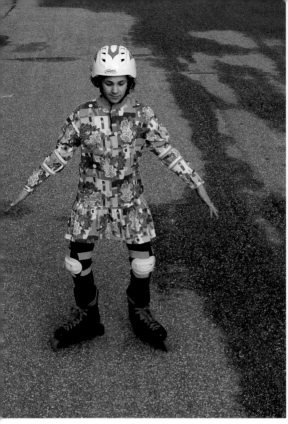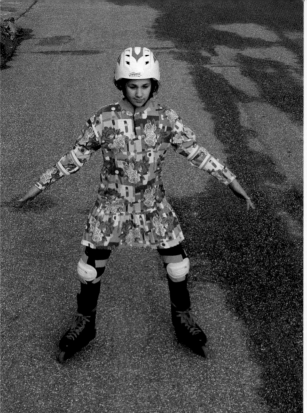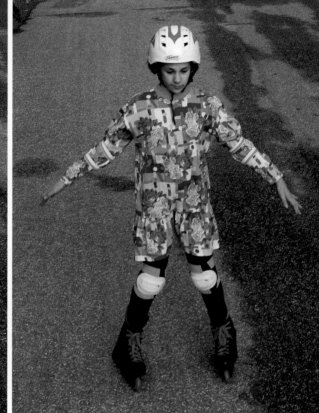

Swizzling is a simple in-and-out movement of the skates. First, force your skates apart, then bring them back together again.

In swizzling backward, you reverse your movements. Begin with the skates together, the toes touching, the heels apart. Extend your arms for balance.

Push from the inside edges, forcing the skates apart. Look over your right shoulder to see where you are going. When your skates are about shoulder-width apart, draw them together again.

Practice swizzling both forward and backward until you're comfortable with the maneuver. It will tend to make turning and backward skating and advanced techniques much easier for you.

8 *Crossovers*

To round a turn, you use a series of crossovers, which involve skating on the wheel edges. The more weight you place on a particular edge, the more decisive your turn will be.

As a beginner, however, you can simply glide through turns. Suppose you want to round a turn in a counterclockwise direction. Concentrate your weight on the inside edge of your right skate, bending in the knees to increase the amount of pressure. Swing your right shoulder forward. Extend your arms for balance. You should sweep through the turn quickly.

Crossovers are a better method of turning. Executed by crossing one skate in front of the other, crossovers enable you to turn at a faster pace than when you merely glide. They're also much more stylish-looking.

To get an idea of what the crossovers feel like, try this drill: Stand erect with your skates side-by-side, your ankles just touching. Pick up the right foot, cross it in front of and over the left, and place it down on the other side of the left skate. Now your feet are crossed. Then draw the left skate back, cross it behind the right, and place it down beside the right. Now your feet are back in their original position.

Now do the drill in the opposite direction. Begin with your left foot, crossing it in front of the right, and placing it down on the other side of the right, so your skates are crossed. Then slide the right skate back and cross it behind the left, placing it down beside the left, so your skates are back in the starting position.

Keep repeating the drill. Your skates are first

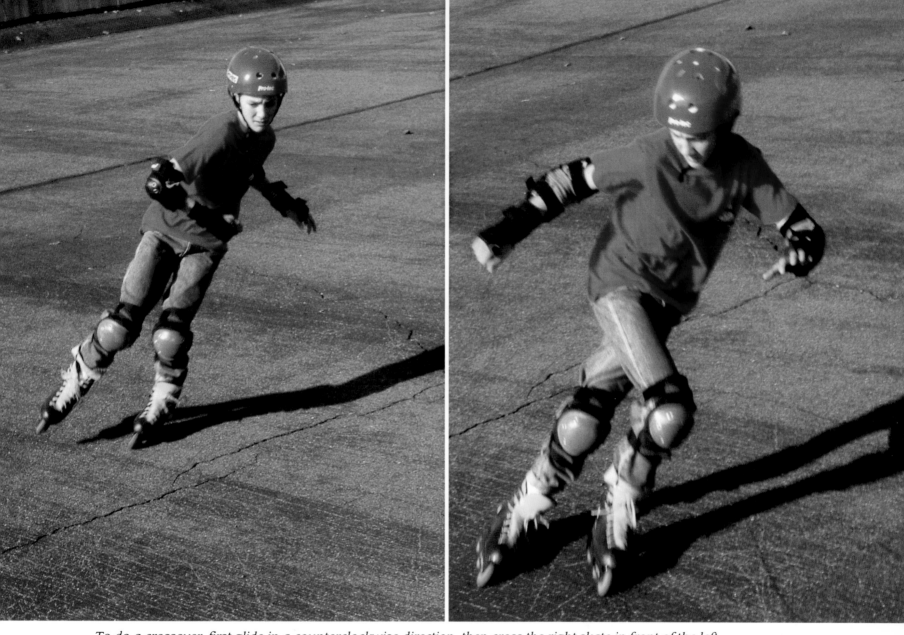

To do a crossover, first glide in a counterclockwise direction, then cross the right skate in front of the left.

parallel, then crossed, then parallel again. Do it to the right; do it to the left. As you do the drill, keep increasing the speed.

Once you've mastered this drill, a crossover turn should not be difficult. As you glide in a counterclockwise direction, shift your weight to the outside edge of your left skate and swing your right shoulder forward. This makes it easy for you to swing your right foot forward, crossing it in front of the left. Put the right skate down on its inside edge.

Then bring the left foot forward, crossing the toe of the left skate behind the heel of the right skate. Place the left skate down on its outside edge.

Always look in the direction in which you're turning. What you shouldn't do is look down at your skates.

Keep repeating the maneuver—crossing your right skate in front of the left, bringing the left skate forward, and then crossing the right skate in front of the left again. You should fly through the turn.

Once you're able to perform crossovers while skating in a counterclockwise direction, and can do them with confidence and grace, try them in the other direction, clockwise. For most people, a clockwise turn is more difficult to do than one in a counterclockwise direction. You can make the clockwise turn easier by performing the crossover drill described here before you attempt the turn itself.

9 *Skating Backward*

Skating in a backward direction may seem difficult at first. It just takes time to get used to it. After all, you use the same push-and-glide movements you use when skating forward, except everything is done in reverse.

Begin by swizzling backward. Build up some speed.

As you're gliding with your skates side-by-side, concentrate your weight on one skate, then quickly push off from the inside wheels of that skate. Glide on the other skate.

Then push off from that skate — and glide.

Keep practicing, going slowly at first. Build up speed little by little.

For turning, use backward crossovers. They're similar to those done when skating forward, except your movements are reversed. Before you try backward crossovers, be sure you've mastered backward swizzles. They'll make backward crossovers easier for you.

In trying a backward crossover for the first time, skate backward in a counterclockwise direction. Turn your right shoulder back, then glide on the outside edge of the right skate, keeping your left leg extended in front of you.

Cross the left skate behind the right and place it down on its inside edge. You'll be momentarily cross-legged. Shift your weight to your left foot. Cross the right skate in front of the left, placing it alongside the left, so you're ready for the next stroke.

As you turn, glance over your right shoulder so you'll know where you're headed and that there's no traffic.

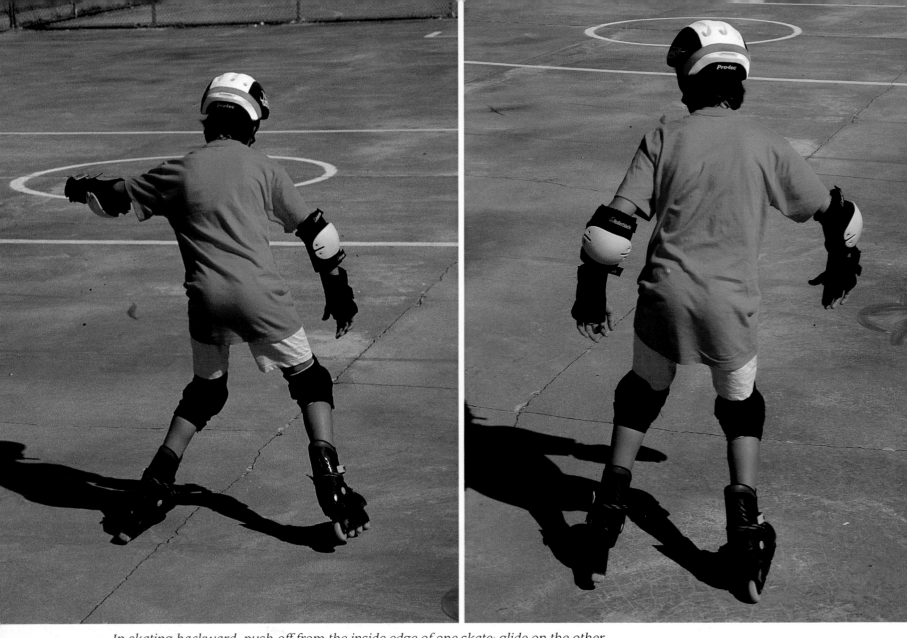

In skating backward, push off from the inside edge of one skate; glide on the other.

10 Sidesurfing

Sidesurfing is an artistic maneuver in which you glide in a circle with your skates turned so that the heels are facing each other. In roller skating, it's called the spread eagle. Once you're skilled in controlling edges, it should be no problem for you.

Begin by gliding in a counterclockwise direction, your skates side-by-side. Concentrate your weight on the inside edge of your right skate. Turn your upper body so that your right shoulder leads.

Pick up the left skate, turn it one-half turn, and place it down so the heel of the left skate is opposite the heel of the right skate. Spread your feet and extend your arms. Your weight should be evenly balanced on the inside edges of both skates. You're still traveling in a counterclockwise direction, your right skate leading as you go.

In sidesurfing, keep your weight evenly balanced on both skates.

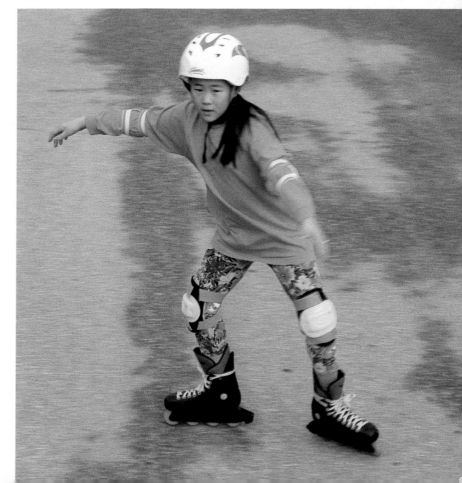

11 The Arabesque

Common to ballet, the arabesque is a pose in which you glide on one skate, your arms out to the sides, with the other leg extended behind. Hold the position as you glide through a full circle. In figure skating the maneuver is known as the spiral.

Begin by gliding in a counterclockwise direction on the inside edge of your right skate. Extend the left skate out behind your body, keeping the leg straight. Put your arms out to the side.

Arch your back so that your head and left leg are higher than your body. Turn the left foot out and point the toe gracefully.

With its emphasis on control and balance, the arabesque is one of the basic maneuvers common to artistic skating, which includes a wide variety of spins, jumps, and dance steps. All of these, no matter how spectacular they appear, are based upon proper edges and body positions.

A graceful maneuver, the arabesque is common to artistic skating — and ballet.

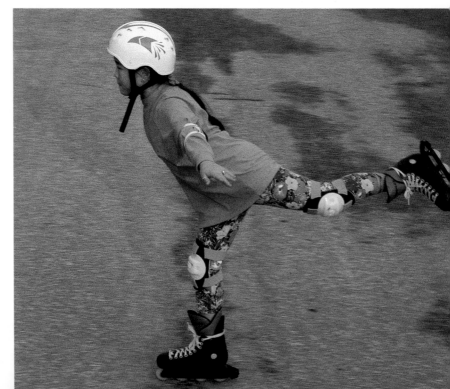

36

12 Roller Hockey

According to the *Guiness Book of World Records,* roller hockey is more than a century old, having first been played at a rink in London, England, in the 1870s. It was called rink polo in those days, not roller hockey, and was played on roller skates. Now, of course, it is also played on in-line skates.

The New York City Department of Parks created what is believed to be the first roller hockey rink in the United States in 1960 in the borough of Queens. Of course, you don't need a specially built rink to play the game. Players also compete on outdoor basketball courts and tennis courts and city streets.

Championship facilities for roller hockey are 180 to 200 feet in length and 85 feet in width. But to play the game on an informal basis, all you really need is a hard-surfaced open space. You can even play on a blacktopped driveway, using only one goal, formed perhaps from a pair of trash barrels (spaced six feet apart). After one team scores, it defends the goal and the other team becomes the attacking team. The first team to score a predetermined number of goals—usually five—is the winner.

No matter where you play the game, you need protective equipment. This includes short, hockey-type padded pants, knee, elbow, and shin pads, and a helmet with a face shield. You also need a protective cup.

Ultra-Wheels is one of the companies that offers skates especially designed for roller hockey. They feature wheels on which the edges are more rounded than on standard wheels, which makes for greater maneuverability. The boot, with its heavy-duty toe, is designed to take punishment in battle. The boot's reinforced tongue protects the instep. Street King is the

name for these roller hockey skates.

Roller hockey sticks feature laminated wood shafts. Choose either a right or left curve, depending on whether you're a right-handed or left-handed shooter. Be sure to pick out a stick that's the right length. Try this test: Stand the stick upright in front of you. The end of the shaft should just reach your chin.

Roller hockey's puck is not the hard rubber disc used in ice hockey. Instead, it's made of weighted plastic, so it will slide smoothly over virtually any type of surface.

The sport can also be played with a ball, a "no bounce" plastic ball that is 2¾ inches in diameter, which is about the size of a tennis ball. However, at 5½ ounces, it weighs more than twice as much as a tennis ball. Roller hockey balls can be purchased at sporting goods stores.

Rather than having six players, as in ice hockey, a roller hockey team has five—two defensemen, two forwards, and a goalie. There are also important differences in the rules. Checking is not allowed and there is no offsides rule. You can move the puck up the rink at will, without having to be concerned whether one or more of your teammates is out of position.

These variations in the rules make for a much faster game than ice hockey. Action is almost continuous from the opening face-off and there are more breakaways. Because of the faster pace, roller hockey games are limited to 15-minute halves.

Forwards have to be able to skate very fast. Their chief responsibility is to be able to break free of opposing defensemen and receive passes or score goals. As this suggests, they have to be skilled stickhandlers and shooters.

Defensive players have to be exceptionally skilled at skating backwards, while trying to

For roller hockey, facemasks are a must.

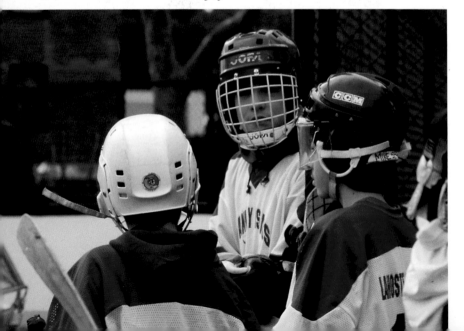

12 *Roller Hockey*

According to the *Guiness Book of World Records*, roller hockey is more than a century old, having first been played at a rink in London, England, in the 1870s. It was called rink polo in those days, not roller hockey, and was played on roller skates. Now, of course, it is also played on in-line skates.

The New York City Department of Parks created what is believed to be the first roller hockey rink in the United States in 1960 in the borough of Queens. Of course, you don't need a specially built rink to play the game. Players also compete on outdoor basketball courts and tennis courts and city streets.

Championship facilities for roller hockey are 180 to 200 feet in length and 85 feet in width. But to play the game on an informal basis, all you really need is a hard-surfaced open space. You can even play on a blacktopped driveway,

using only one goal, formed perhaps from a pair of trash barrels (spaced six feet apart). After one team scores, it defends the goal and the other team becomes the attacking team. The first team to score a predetermined number of goals—usually five—is the winner.

No matter where you play the game, you need protective equipment. This includes short, hockey-type padded pants, knee, elbow, and shin pads, and a helmet with a face shield. You also need a protective cup.

Ultra-Wheels is one of the companies that offers skates especially designed for roller hockey. They feature wheels on which the edges are more rounded than on standard wheels, which makes for greater maneuverability. The boot, with its heavy-duty toe, is designed to take punishment in battle. The boot's reinforced tongue protects the instep. Street King is the

name for these roller hockey skates.

Roller hockey sticks feature laminated wood shafts. Choose either a right or left curve, depending on whether you're a right-handed or left-handed shooter. Be sure to pick out a stick that's the right length. Try this test: Stand the stick upright in front of you. The end of the shaft should just reach your chin.

Roller hockey's puck is not the hard rubber disc used in ice hockey. Instead, it's made of weighted plastic, so it will slide smoothly over virtually any type of surface.

The sport can also be played with a ball, a "no

For roller hockey, facemasks are a must.

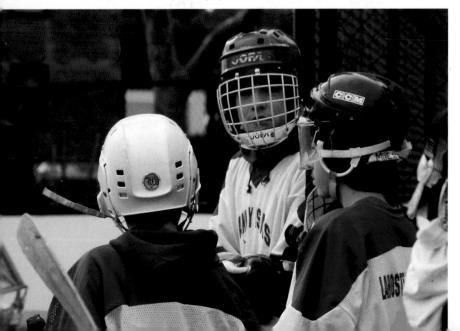

bounce" plastic ball that is 2¾ inches in diameter, which is about the size of a tennis ball. However, at 5½ ounces, it weighs more than twice as much as a tennis ball. Roller hockey balls can be purchased at sporting goods stores.

Rather than having six players, as in ice hockey, a roller hockey team has five — two defensemen, two forwards, and a goalie. There are also important differences in the rules. Checking is not allowed and there is no offsides rule. You can move the puck up the rink at will, without having to be concerned whether one or more of your teammates is out of position.

These variations in the rules make for a much faster game than ice hockey. Action is almost continuous from the opening face-off and there are more breakaways. Because of the faster pace, roller hockey games are limited to 15-minute halves.

Forwards have to be able to skate very fast. Their chief responsibility is to be able to break free of opposing defensemen and receive passes or score goals. As this suggests, they have to be skilled stickhandlers and shooters.

Defensive players have to be exceptionally skilled at skating backwards, while trying to

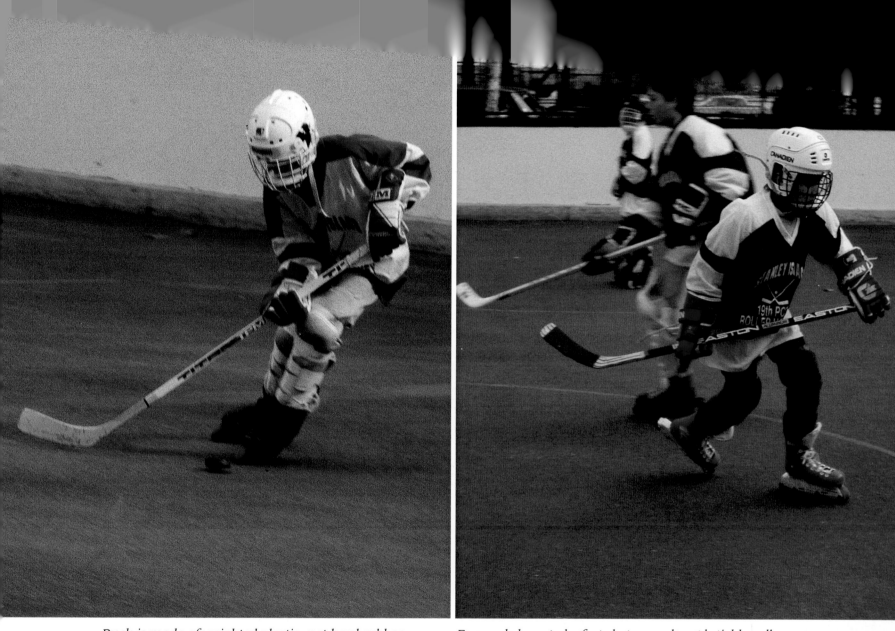

Puck is made of weighted plastic, not hard rubber.

Forwards have to be fast skaters and good stickhandlers.

steal the puck from an onrushing forward. But defensemen also have to know how to stick-handle, pass, and shoot.

Goalies require quickness, the ability to maneuver in the net to block or catch a flying puck. Since the puck in roller hockey has more bounciness than in ice hockey, the goalie's job is harder. He (the goalie is seldom a she) has to be especially alert for rebounds, always ready to pounce upon and smother a loose puck.

Forwards and defensemen use the heel stop or T-stop only when traveling at a slow pace.

When speeding along, they prefer what's called the power stop. It's executed by making a very tight 180-degree turn and braking your forward movement with the inside edges of both skates. It's not for beginners.

During the early 1990s, roller hockey grew by leaps and bounds. Teams and leagues sprang up in southern California, New York City, Phoenix, Minneapolis, Dallas, Chicago, Boston, Philadelphia, and Toronto, Canada. For information about roller hockey in your area, call 1-800 255-7472.

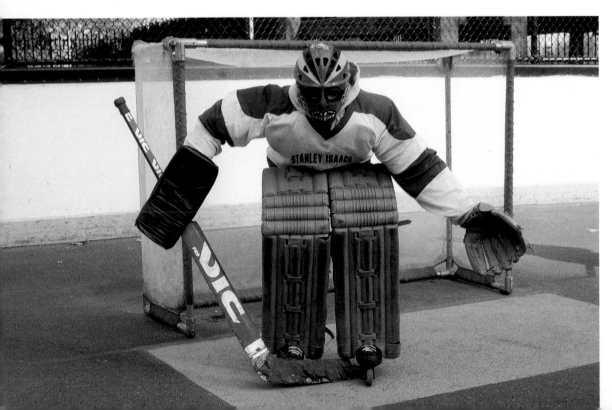

Goalies require quickness, courage — and lots of equipment.

13 Racing

Speed skaters on in-line skates, whisking along a park road or city streets in colorful stretch nylon and protective headgear, can reach speeds of 25 miles per hour on the flats and beyond 35 mph on downhill stretches. They are among the fastest self-propelled athletes in the world.

Their long, gliding strides are made possible by special five-wheeled skates with low-cut boots. Once in high gear, they skate in a crouched position. This assures greater power and cuts down on wind resistance. Their hands are behind them, resting on the lower back, to avoid wasted motion and to conserve energy.

In organized racing competition, most races are 10 kilometers, a distance equal to 6.2 miles. But there are also sprints of from 200 to 500 meters (500 meters is about ⅓ of a mile) and distance races of from 50 to 100 kilometers (31 to 62 miles).

The world's longest race for in-line skaters, a 138-mile journey from Fresno to Bakersfield in California, took place in the spring of 1991. Sandy Snakenburg, twenty-nine years old and a chef in a vegetarian restaurant, placed first among the seventeen starters who finished the race. His winning time was 9:21:42 (9 hours, 21 minutes, 42 seconds).

Average skaters are able to complete a 10K race in less than 25 minutes. The world record in the event, held by Stephen Ridley, is 16:51.30 (16 minutes, 51.30 seconds).

Speed skaters prefer five-wheel skates because their added length makes for longer strides, which assure greater speed. The boot is cut low to make it light in weight.

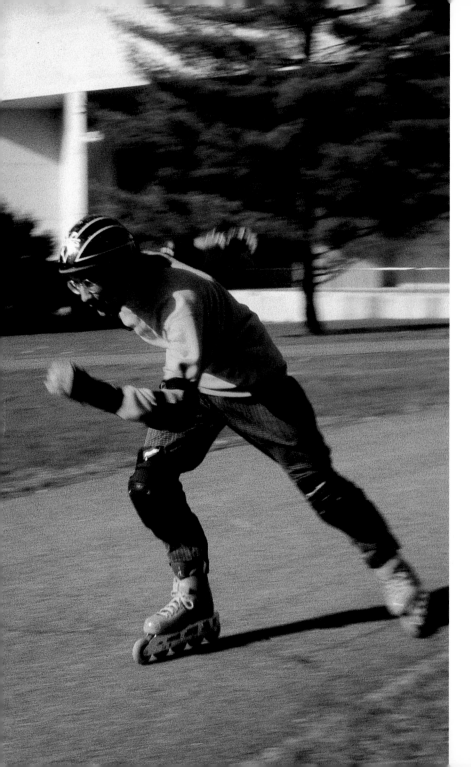

The fit should be the same as in a regular skate—snug but comfortable. If the heel slides up and down, the boot is too big. If the toes feel cramped when you stand erect, it's too small.

Speed skaters pay a great deal of attention to wheels and bearings. They prefer wheels that are on the soft side, with durometer ratings of from 75 to 78. A softer wheel flattens with use, providing greater traction. This results in a more powerful stroke. Buy the highest quality bearings you can afford.

You should wear the same protective gear as when skating for fun. This includes elbow pads, kneepads, and wrist guards. And never go without a helmet.

If you become involved in distance racing, your equipment should also include a water bottle. Experts recommend taking a drink every 15 minutes to guard against dehydration.

The basic idea in speed skating is to keep the wheels in contact with the surface for as long as possible. This not only results in a long stroke, it also helps to keep your weight forward.

Speed skaters use long, rhythmic strides.

On uphill climbs (or in sprint races), pump your arms forward and back. Be sure they *go straight* forward and *straight* back. What you shouldn't do is cross your hands in front of your body when you pump.

To conserve energy when the terrain is flat, skate with your hands behind you. This causes you to bend forward from the waist, which enables you to maintain good speed over a long distance.

To be successful as a speed skater, you have to develop a sense of pace. You can't skate at full speed for the entire distance. As a beginner, try starting out at a relatively slow speed and skate at a medium speed for the race's first half. Then, if you feel capable of doing so, speed up. Keep increasing your speed as the finish gets closer.

If you're serious about speed skating, you'll train hard. This means daily workouts at a variety of speeds and distances. For an important event, skaters are likely to train for several months.

In distance racing, skating with your hands behind you helps conserve energy.

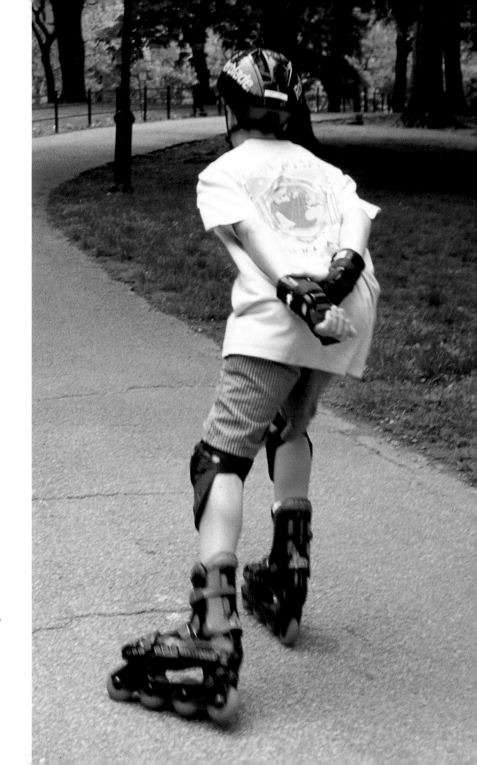

14 *Taking Care of Your Skates*

Even though they're made of tough polyurethane, wheels wear down and have to be replaced. How often you have to buy replacements depends on several factors—how often you skate, the type of surface on which you skate, and how much you weigh. Some skaters need new wheels after only a few months, while others can go a year or more with the same wheels. New wheels can be purchased at the same shop where you bought your skates.

You can extend the life of the wheels, maybe even double it, by repositioning them. Whenever the wheels begin to look lopsided, remove them and reverse their positions. With each wheel, the least worn edge becomes the edge that will get the most wear.

You can also add miles to the life of the wheels by rotating them. In the case of three-wheel skates, the front wheel becomes the rear wheel; the rear wheel becomes the middle wheel, and the middle wheel becomes the front wheel.

To reposition or rotate the wheels, or change bearings, you need a socket wrench, a Phillips screwdriver, and an Allen wrench, sometimes called a hex wrench. All of these are contained in a special pocket-size tool many skate shops sell.

With four-wheel skates, rotate like this:
• The No. 1 wheel (the wheel at the front of the skate) changes place with the No. 3 wheel.
• The No. 4 wheel changes place with the No. 2 wheel.

With five-wheel skates, the No. 1 wheel is not rotated. The other wheels are rotated as follows.

• The No. 2 wheel becomes the No. 4 wheel.

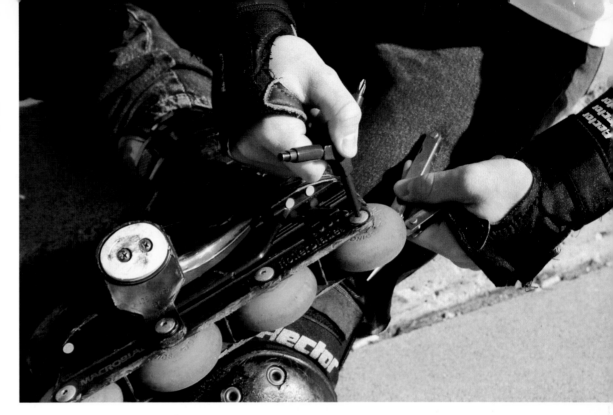

Pocket-size tool like this one, sold at most skate shops, is vital in repairing skates.

• The No. 3 wheel becomes the No. 2 wheel.
• The No. 4 wheel becomes the No. 5 wheel.
• The No. 5 wheel becomes the No. 3 wheel.

Before you replace the wheels, wipe the bearings clean with a soft cloth. Tighten each wheel until there is slight resistance when you spin it. Then loosen the setting a tiny bit.

You will also have to get a new brake occasionally because it gets worn down, too. Replace the brake when it has worn to a point that the bolt that attaches it to the skate begins to scrape the pavement.

Keep your skates clean by wiping them with a damp cloth after you've used them. Remove the liners and dry them thoroughly.

And before you put on your skates, check the nuts that secure the wheels to their axles to be sure they're tight. Also try to wiggle each wheel; there should be no side-to-side "play." Skates that are defective in any way can cause a spill and injury.

15 *Skating Smart*

While in-line skating is easy to learn and can make for exciting fun from the first day you try the sport, it also provides an element of risk. Falling down can lead to bumps and bruises, strains and sprains—and even worse.

To help prevent injury, skate smart by following these rules of the road:

- Every time you put on skates, also wear protective gear, including a helmet, wrist guards, and knee and elbow pads.
- Be sure you know the basics—pushing and gliding, stopping, swizzling, and crossover turns—before you take to the road.
- Always skate under control, meaning never travel so fast you can't stop quickly and smoothly.
- Keep to the right side of paths, trails, and sidewalks.
- Overtake pedestrians, cyclists, and other skaters on the left.
- Observe all local traffic regulations.
- Avoid wet spots and any oil or debris on the trail, also uneven or broken pavement.
- Always yield to pedestrians.

Never skate without wearing a helmet, wrist guards, and elbow and kneepads.

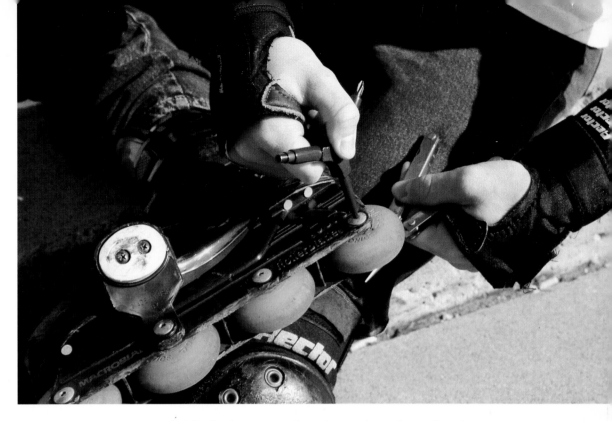

Pocket-size tool like this one, sold at most skate shops, is vital in repairing skates.

• The No. 3 wheel becomes the No. 2 wheel.
• The No. 4 wheel becomes the No. 5 wheel.
• The No. 5 wheel becomes the No. 3 wheel.

Before you replace the wheels, wipe the bearings clean with a soft cloth. Tighten each wheel until there is slight resistance when you spin it. Then loosen the setting a tiny bit.

You will also have to get a new brake occasionally because it gets worn down, too. Replace the brake when it has worn to a point that the bolt that attaches it to the skate begins to scrape the pavement.

Keep your skates clean by wiping them with a damp cloth after you've used them. Remove the liners and dry them thoroughly.

And before you put on your skates, check the nuts that secure the wheels to their axles to be sure they're tight. Also try to wiggle each wheel; there should be no side-to-side "play." Skates that are defective in any way can cause a spill and injury.

15 *Skating Smart*

While in-line skating is easy to learn and can make for exciting fun from the first day you try the sport, it also provides an element of risk. Falling down can lead to bumps and bruises, strains and sprains—and even worse.

To help prevent injury, skate smart by following these rules of the road:

- Every time you put on skates, also wear protective gear, including a helmet, wrist guards, and knee and elbow pads.
- Be sure you know the basics—pushing and gliding, stopping, swizzling, and crossover turns—before you take to the road.
- Always skate under control, meaning never travel so fast you can't stop quickly and smoothly.
- Keep to the right side of paths, trails, and sidewalks.
- Overtake pedestrians, cyclists, and other skaters on the left.
- Observe all local traffic regulations.
- Avoid wet spots and any oil or debris on the trail, also uneven or broken pavement.
- Always yield to pedestrians.

Never skate without wearing a helmet, wrist guards, and elbow and kneepads.

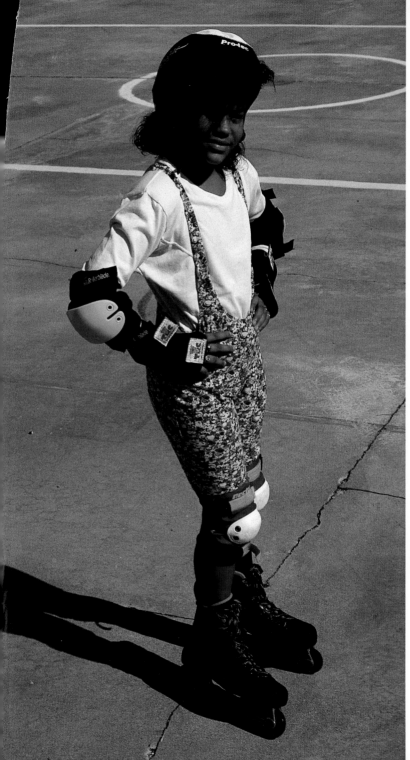

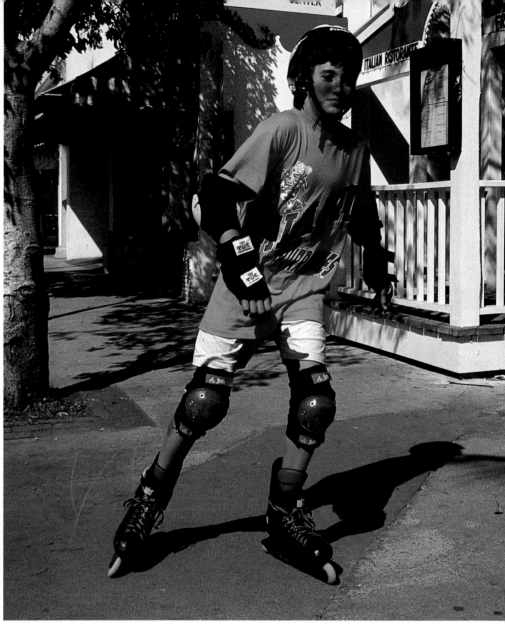

Never skate so fast you can't stop quickly and smoothly.

Glossary

arabesque — A maneuver in which the skater glides on one skate, arms out to the side, the other leg extended behind.

crossover — A type of turn that is executed by repeatedly crossing one skate in front of the other.

cross training — Using one sport to practice the techniques of another (using in-line skates to train for ice hockey or skiing, for instance).

durometer rating — The method of classifying skate wheels according to their hardness. The higher the durometer number, the harder (and slower) the wheel.

edge — On a pair of skates, either side of each set of wheels.

footbed — The padded insole or liner that fits inside the skate boot.

outside edge — On a pair of skates, either of the two edges that are on the outside of the wheels.

polyurethane — A tough thermoplastic used in the manufacture of skate wheels.

sidesurfing — A maneuver in which the skater glides with the heels of the skates facing one another, feet wide apart, and arms extended.

T-stop — A method of stopping in which the wheels of one skate are dragged at right angles behind the other skate.

wheelbase — On a skate, the distance from the center of the front axle to the center of the rear axle.

48

9698, 00.10